The ABCs of Dog Breeds

Letter A

DOG BREEDS SERIES **VOL. 1**

Copyright© 2021

What is a dog breed?

To understand better what a dog breed is, let's take a look at some of the popular definitions.

The Dog Digest says this about a dog breed:
"A dog breed is a particular strain or dog type that was purposefully bred by humans to perform specific tasks, such as herding, hunting, and guarding."

Merriam-Webster describes what breed means:
A group of usually domesticated animals or plants presumably related by descent from common ancestors and visibly similar in most characters.

The third definition we will look into is from the Oxford dictionary:
A particular type of animal that has been developed by people in a certain way, especially a type of dog, cat or farm animal.

From these definitions, we can conclude that a dog breed refers to a group of dogs that share almost the same physical characteristics and personalities. In most cases, dog breeds were purposely developed by people to obtain desirable traits that different dogs shared.

Below is the first part of a comprehensive list of dog breeds. Categorized in alphabetical order, you will be able to find important information about each breed. *Let's start!*

A

AFADOR

The Afador is a mixed breed dog—a cross between the Afghan Hound and Labrador Retriever dog breeds. Loyal, energetic, and affectionate, these pups inherited some of the best qualities from both of their parents.

Afadors are also sometimes known as the Afghan Lab. You can find these mixed breed dogs in shelters and breed specific rescues, so remember to always adopt! Don't shop if you're looking to add an Afador to your home!

AFFENPINSCHER

Dogs of the Affenpinscher breed were originally created to act as ratters in homes, stables, and shops. Bred down in size, they moved up in the world, becoming ladies' companions. Today, they are happy, mischievous companion dogs.

Although these are purebred dogs, you may still find them in shelters. You will find that these dogs are loving, loyal, and protective despite their small size.

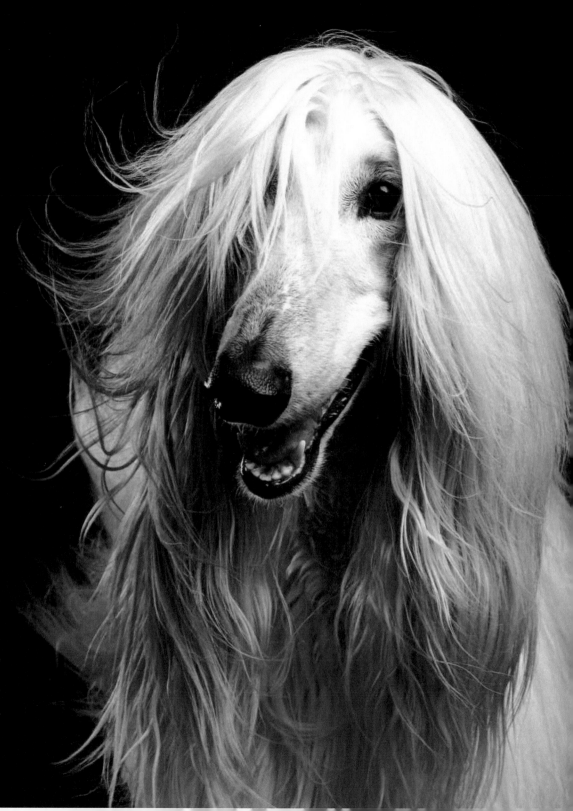

AFGHAN HOUND

The Afghan Hound is elegance personified. This unique, ancient dog breed has an appearance quite unlike any other: dramatic silky coat, exotic face, and thin, fashion-model build. Looks aside, Afghan enthusiasts describe this hound as both aloof and comical.

Hailing from Afghanistan, where the original name for the breed was Tazi, the Afghan is thought to date back to the pre-Christian era and is considered one of the oldest dog breeds.

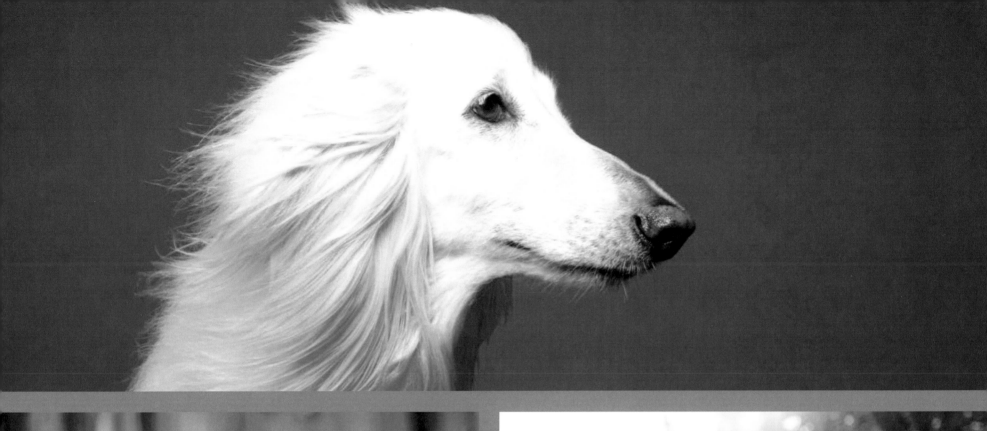
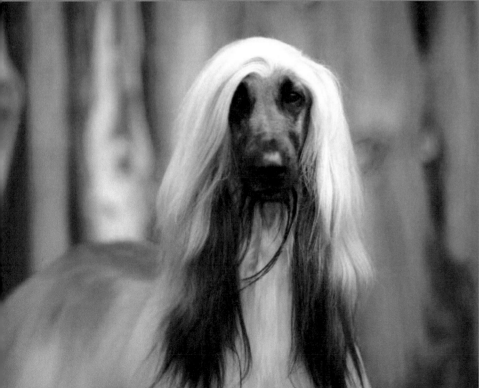

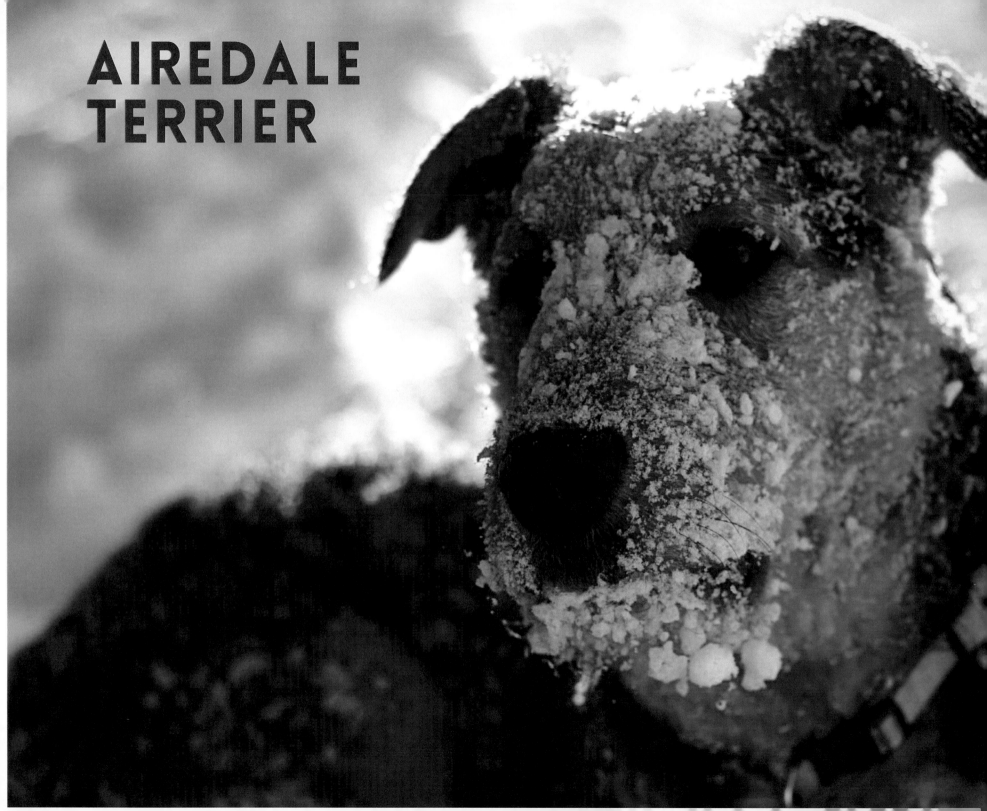

AIREDALE TERRIER

Known as the "King of Terriers," the Airedale is indeed the largest of all terriers. The dog breed originated in the Aire Valley of Yorkshire and was created to catch otters and rats in the region between the Aire and Wharfe Rivers. An able sporting dog, they became an ideal working dog as well, proving their worth during World War I. Intelligent, outgoing, and confident, the Airedale Terrier possesses a wonderful playful streak that delights their humans.

These dogs have high energy and need plenty of exercise, if you can meet the breed's physical needs and provide them with space to run, preferably in the form of a big yard with a tall, secure fence, then you'll be rewarded with a playful, loving companion for the whole family—even kids!

AKBASH

The Akbash is a rare, purebred dog from the country of Turkey. Loyal, alert, and intelligent, these pups have some of the best qualities you could ask for.

These pooches go by several other names, including Coban Kopegi, Akbaş Çoban Köpeği, and Askbash Dog.

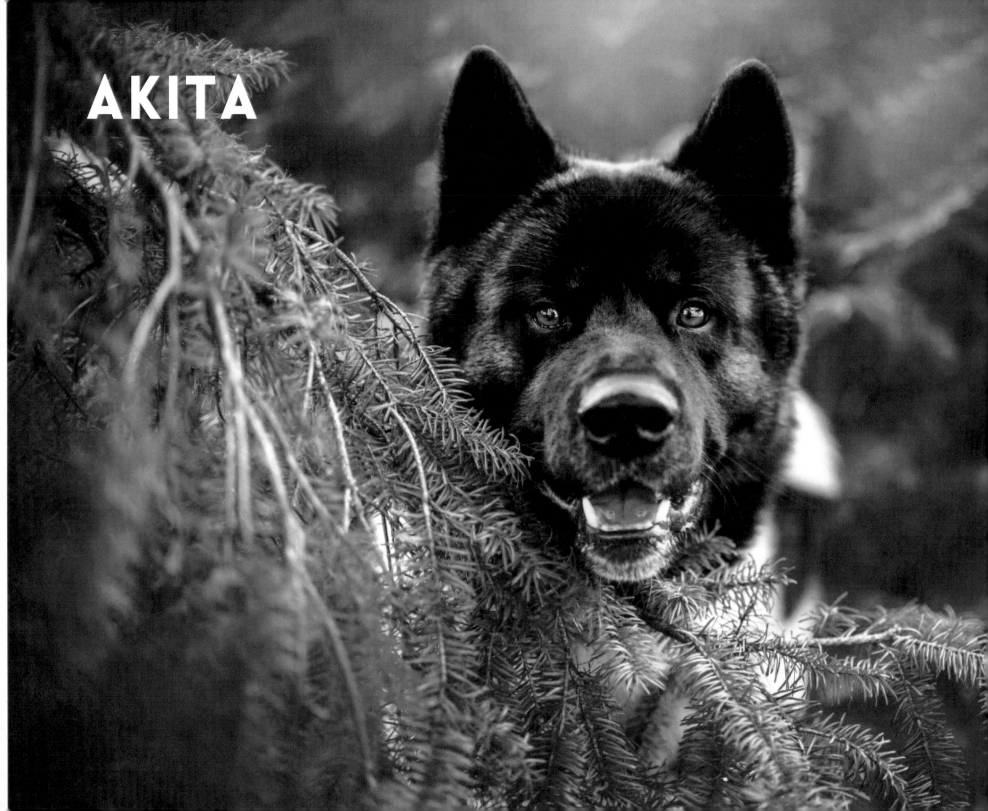
AKITA

The Akita is a large and powerful dog breed with a noble and intimidating presence. They were originally used for guarding royalty and nobility in feudal Japan. These dogs also tracked and hunted wild boar, black bear, and sometimes deer.

The Akita does not back down from challenges and does not frighten easily. Consequently, they are fearless and loyal guardians of their families. Yet they are also affectionate, respectful, and amusing dogs when properly trained and socialized.

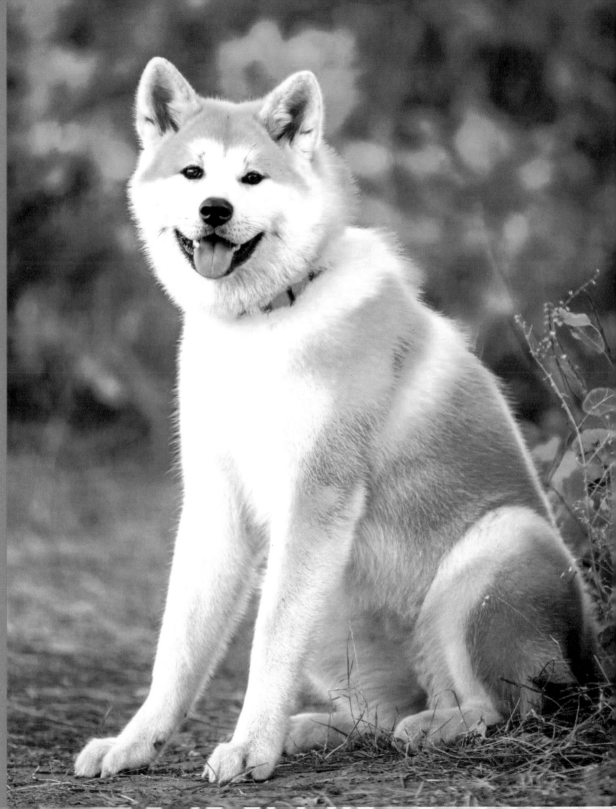

AKITA
CHOW

The Akita Chow is a mixed breed dog—a cross between the Akita and Chow Chow dog breeds. Large, independent, and loyal, these pups inherited some of the best traits from both of their parents. Akita Chows are quiet, and while they may not be overly affectionate, they are incredibly protective and loyal.

They wouldn't be suitable for an apartment but would love a house with a yard so they have plenty of room to stretch their legs. Akita Chows would make great walking, running, or hiking companions. This is a highly intelligent dog.

ALASKAN KLEE KAI

Small, smart, and energetic, the Alaskan Klee Kai is a relatively new breed that looks like a smaller version of the Siberian Husky. Even the name "Klee Kai" comes from an Inuit term meaning "small dog."

While Alaskan Klee Kais may resemble larger Husky breeds, they have some key differences, especially when it comes to temperament, that distinguish it from its ancestor working class dogs of the north. This breed is more suited to the life of a companion; although, the Alaskan Klee Kai shares the high energy of the Husky and demands plenty of exercise.

ALASKAN MALAMUTE

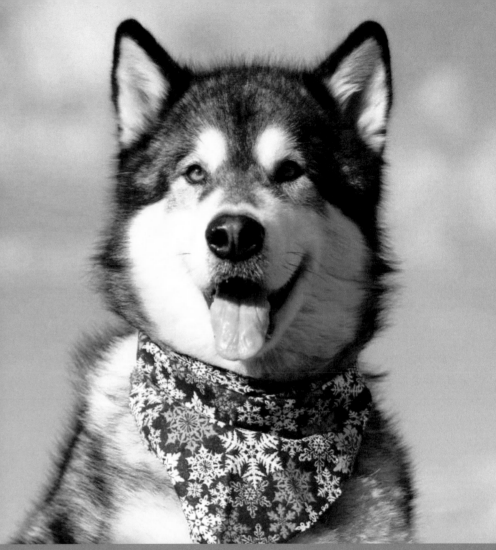

The Alaskan Malamute features a powerful, sturdy body built for stamina and strength. It reigns as one of the oldest dog breeds whose original looks have not been significantly altered. This intelligent canine needs a job and consistent leadership to avoid becoming bored or challenging to handle.

Dogs of this breed are sensitive and need plenty of companionship and open space. They are not well-suited to apartment life, and they are certainly high-shedding pooches who need plenty of grooming to keep their coats healthy.

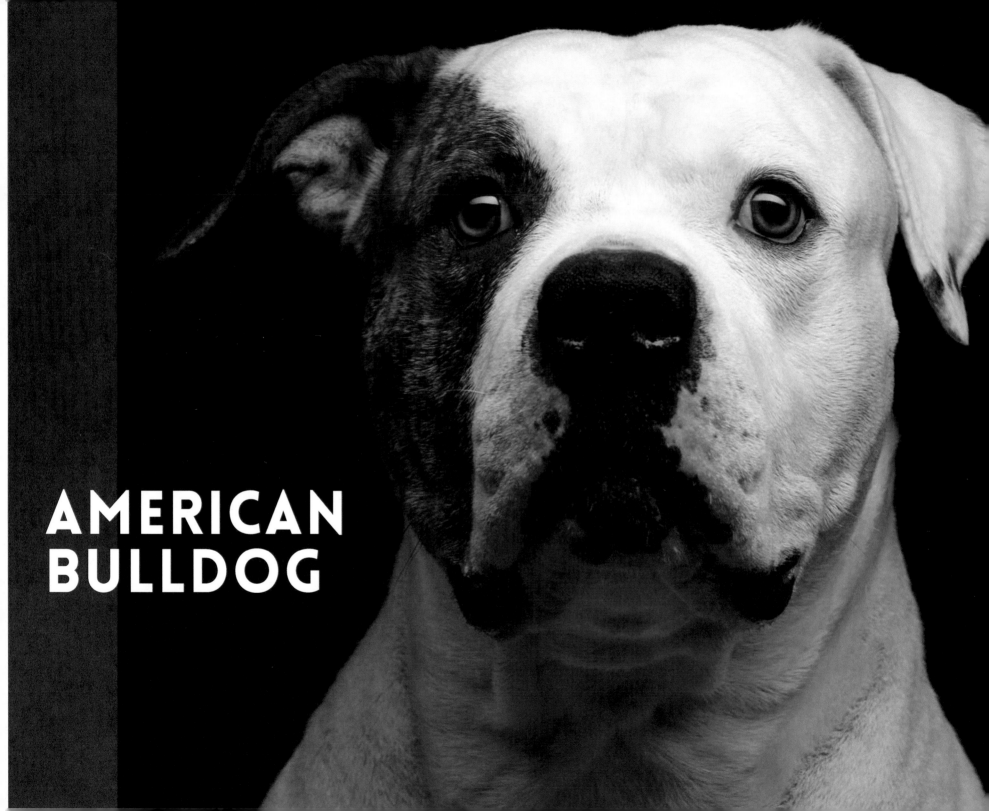

AMERICAN
BULLDOG

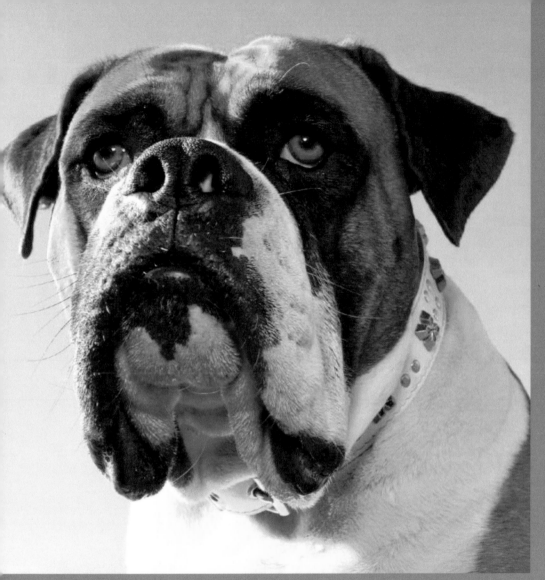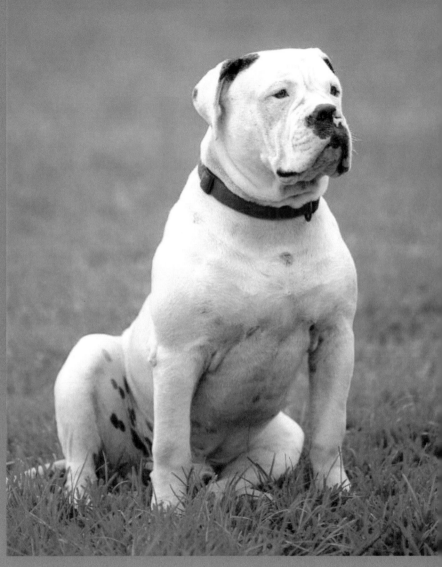

Stocky and muscular, but also agile and built for chasing down stray cattle and helping with farm work. In fact, some are known to jump six feet or more into the air. American Bulldogs are intelligent and affectionate, which makes them great, protective family dogs; although, they have high exercise needs, they can vary in appearance, as there are multiple types, including the Bully or Classic type, also known as the Johnson type, the Standard or Performance type, also called the Scott type, and hybrids of the two.

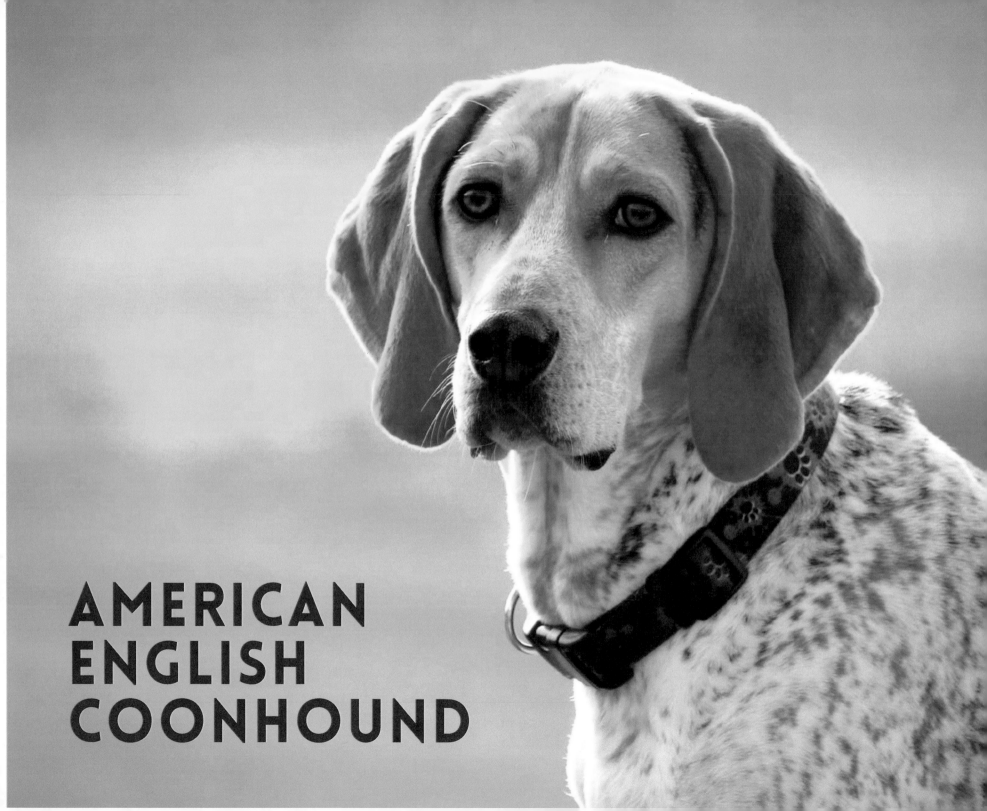

AMERICAN ENGLISH COONHOUND

A descendent of the English Foxhound, the American English Coonhoound is a hunting dog breed known for their speed, endurance, and loud voice in the field. The'll bark and bay at home, too, making them a poor choice if you've got nearby neighbors. These dogs are loving, intelligent, easy to train, and fairly easy to groom. They also need firm, consistent training and lots of mental and physical activity.

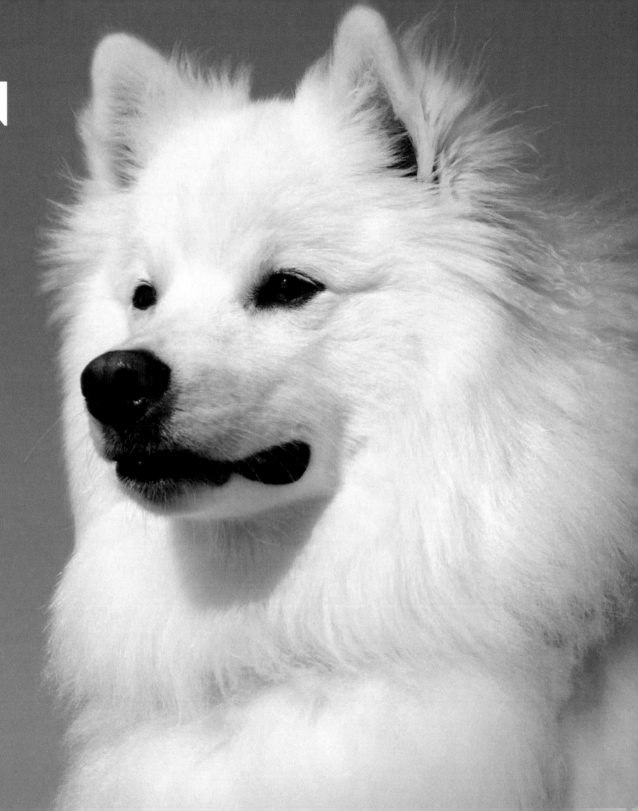

AMERICAN
ESKIMO
DOG

Called "the dog beautiful" by admirers, the American Eskimo Dog, or "Eskie," is a striking canine with their white coat, sweet expression, and black eyes. They're a Nordic dog breed, a member of the Spitz family.

Eskies are lively, active companion dogs who love to entertain and join in on all family activities. They're outgoing and friendly with family and friends, but reserved with strangers. Although the Eskie is a small dog — 10 to 30 pounds — they have a big-dog attitude.

AMERICAN FOXHOUND

Easygoing, sweet, kind, and loyal, the American Foxhound dog breed belongs to a way of life that has continued for more than two centuries, but they have the potential to be a modern-day companion as well.

The American Foxhound's stamina and love of running make them great jogging partners, and their mild nature makes them excellent family dogs, so long as they get the exercise they crave.

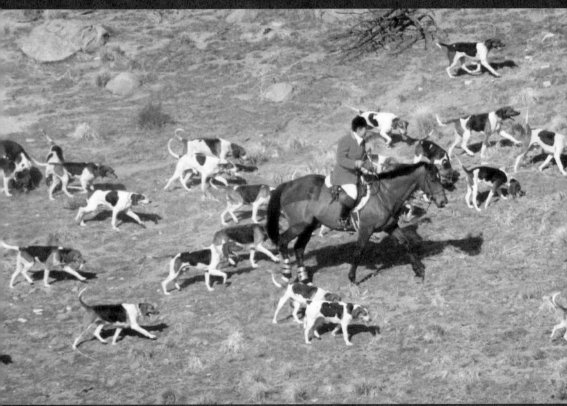

AMERICAN
HAIRLESS
TERRIER

Is the only hairless dog breed indigenous to the United States, and the breed's creation was something of a happy accident. Today, the breed is known as an active companion dog and an especially great choice for allergy sufferers.

Some fans of the new breed abbreviate the name to AHT, while some refer to them as hairless Rat Terriers.

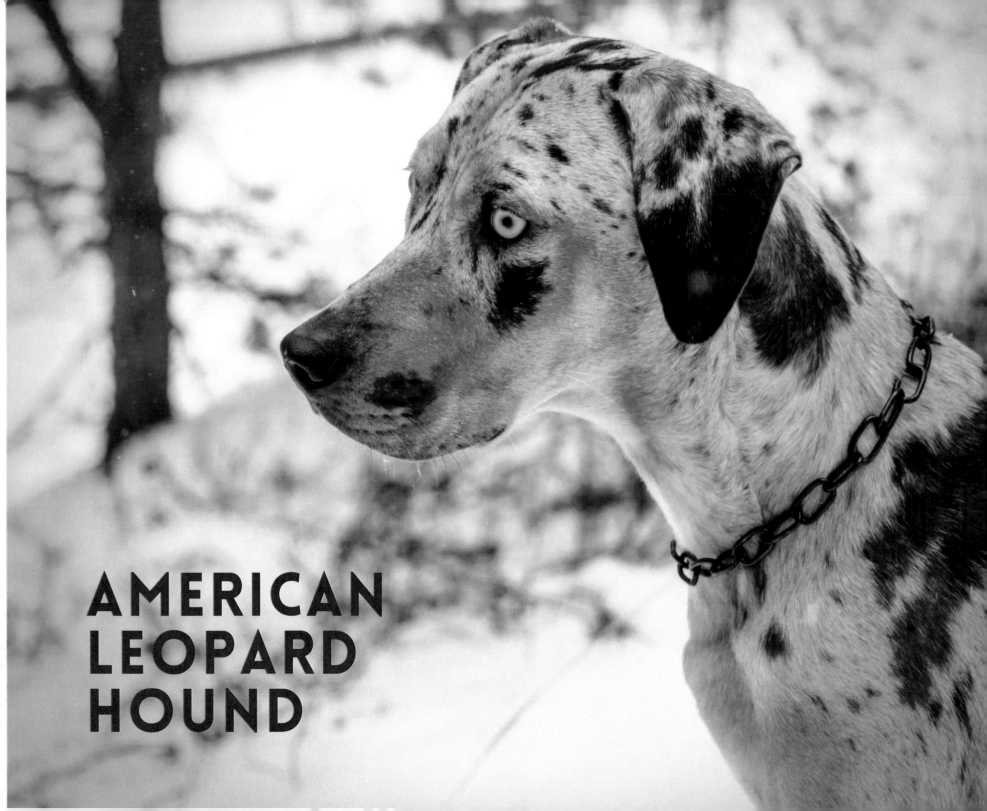

AMERICAN LEOPARD HOUND

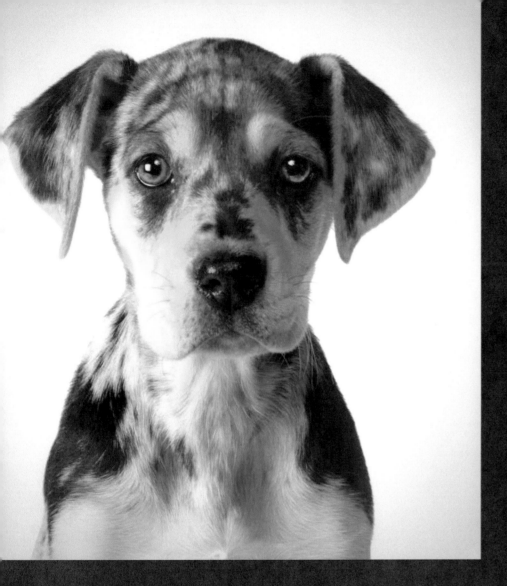

Is a purebred dog whose ancestors came from Mexico by way of Spanish conquistadors who sailed to North America. They are energetic, sociable, and intelligent pooches who possess all-around great traits.

The American Leopard Hound goes by other names, such as the Leopard Cur, American Leopard, and American Leopard Cur. These sweet pups are natural hunting dogs and have very high energy. That means they do best in homes with big yards to run around in. They're able to bond strongly with humans, which makes them well-suited for households of all types, from single pet parents to families with children.

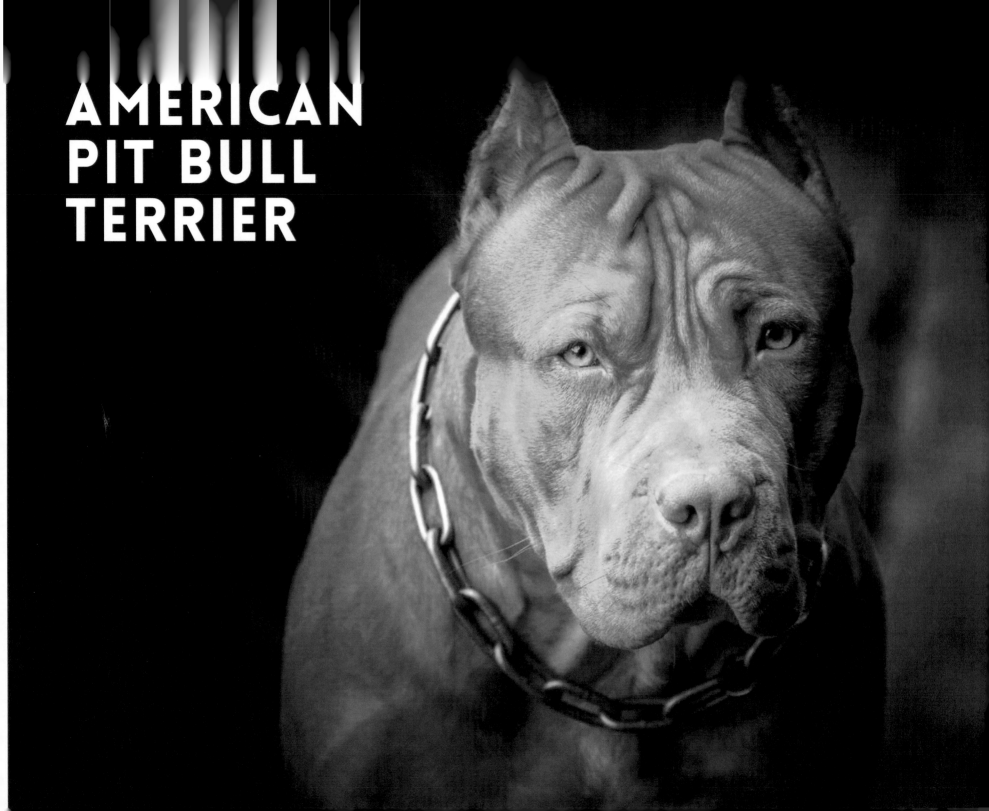

AMERICAN PIT BULL TERRIER

Is a companion and family dog breed. Originally bred to "bait" bulls, the breed evolved into all-around farm dogs, and later moved into the house to become "nanny dogs" because they were so gentle around children.

Their tenacity, gameness, and courage make them popular competitors in the sports of weight pulling, agility, and obedience. Of course, you can also find them living as companions, showering their humans with love and affection.

AMERICAN STAFFORDSHIRE TERRIER

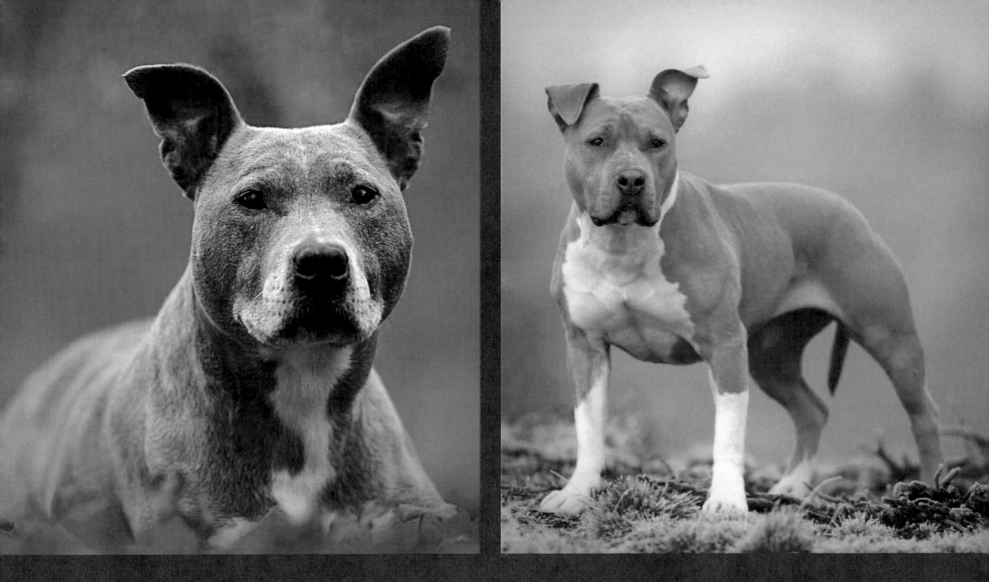

IIs a muscular breed known for being strong for its size; however, they're also loving and affectionate with human family members. American Staffordshire Terriers enjoy nothing more than being with the humans they care about, whether they're out for a jog, playing in the yard, or cuddling up on the couch.

They are intelligent and eager to please, which makes them highly trainable; although, that intelligence means they need mental stimulation. If they don't get it, they'll put those strong jaws to use and chew anything out of boredom.

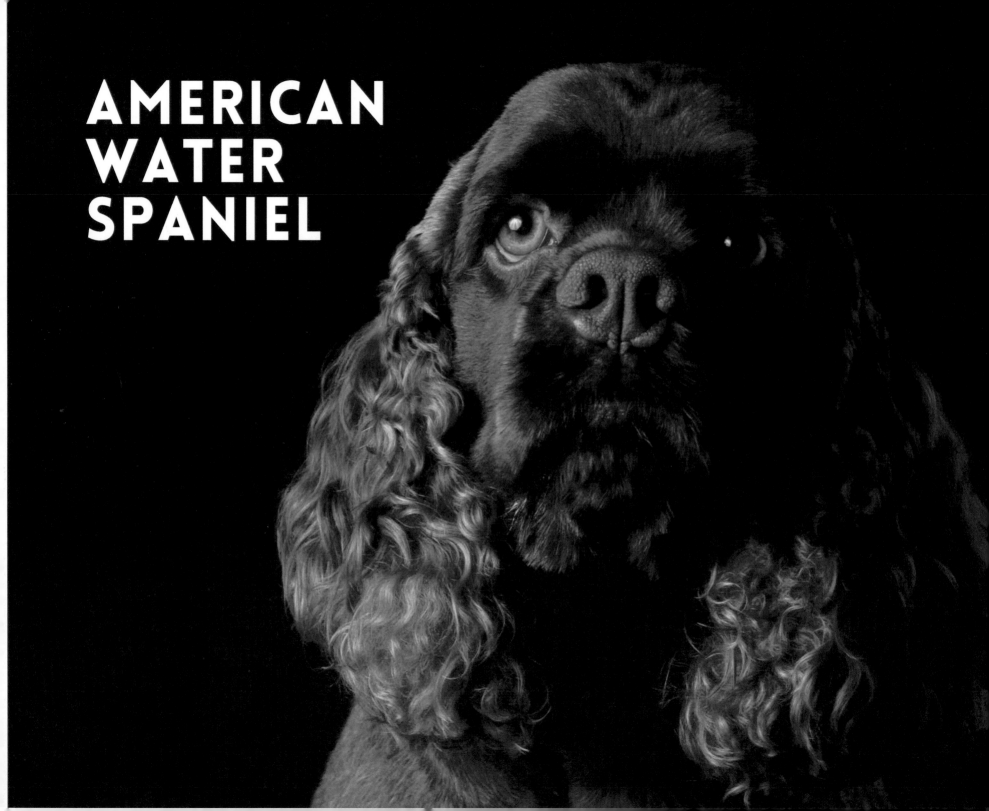

AMERICAN
WATER
SPANIEL

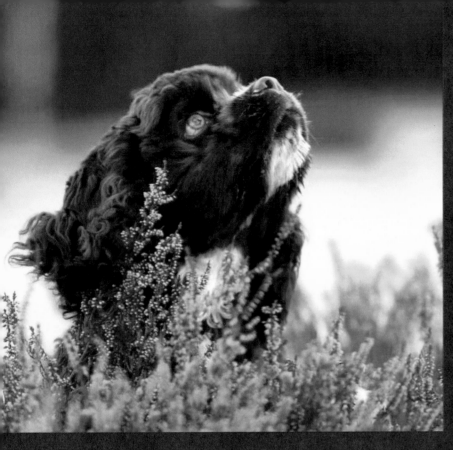

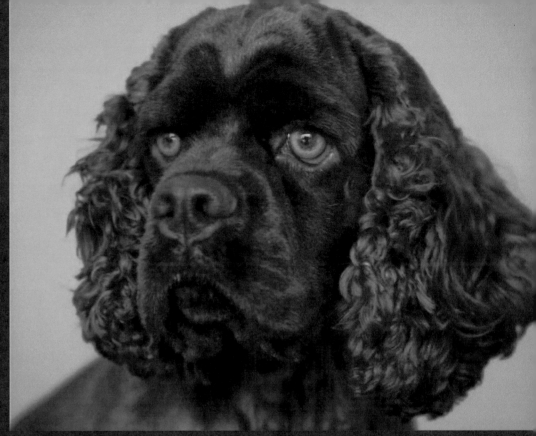

Was bred to be an all-around hunting dog. Specializing in waterfowl, these skilled swimmers will happily retrieve from small boats, protected by their water-resistant double coats.

This breed has the high energy of a dog born to chase and retrieve game, but given enough exercise, they can also make great family companions. If you can keep up and provide plenty of space to run, then this may be the breed for you!

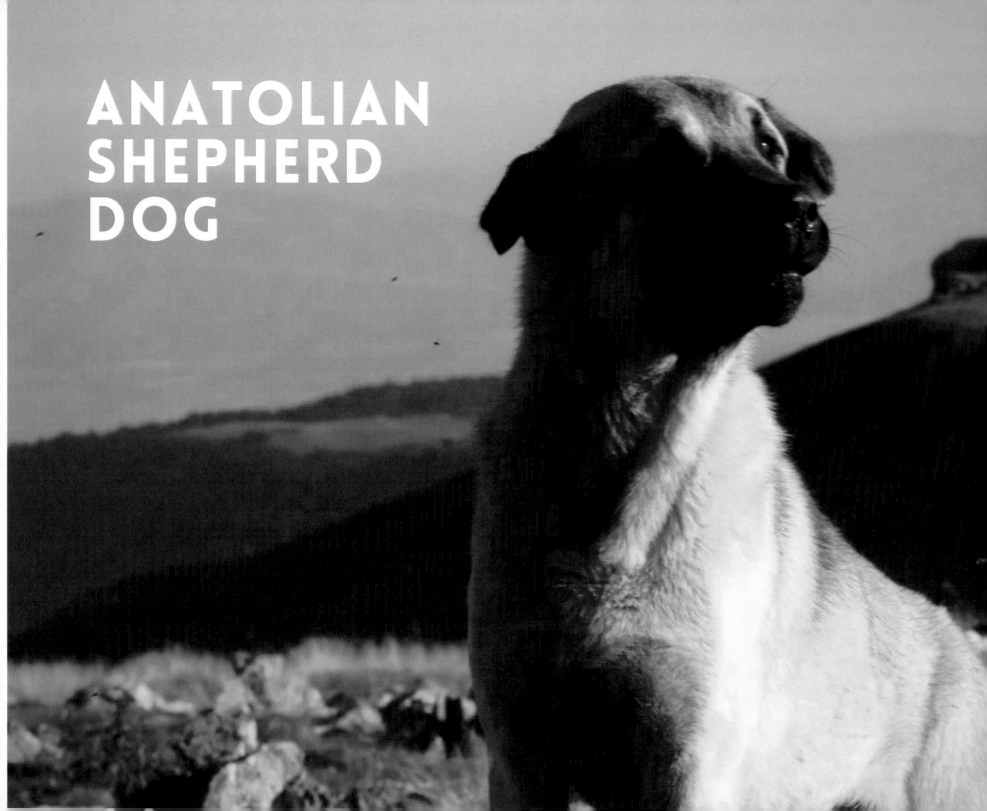

ANATOLIAN SHEPHERD DOG

Is a native of Turkey, where they were bred as a shepherd's companion and livestock guardian. They were created with specific traits to resemble the size and color of livestock they defended so predators wouldn't detect them among the flock.

Sometimes called the Anatolian Karabash Dog or Kangal (which is considered a separate breed by many kennel clubs), they're a fiercely loyal guard dog and a large, impressive dog breed, frequently weighing 120 to 150 pounds at maturity.

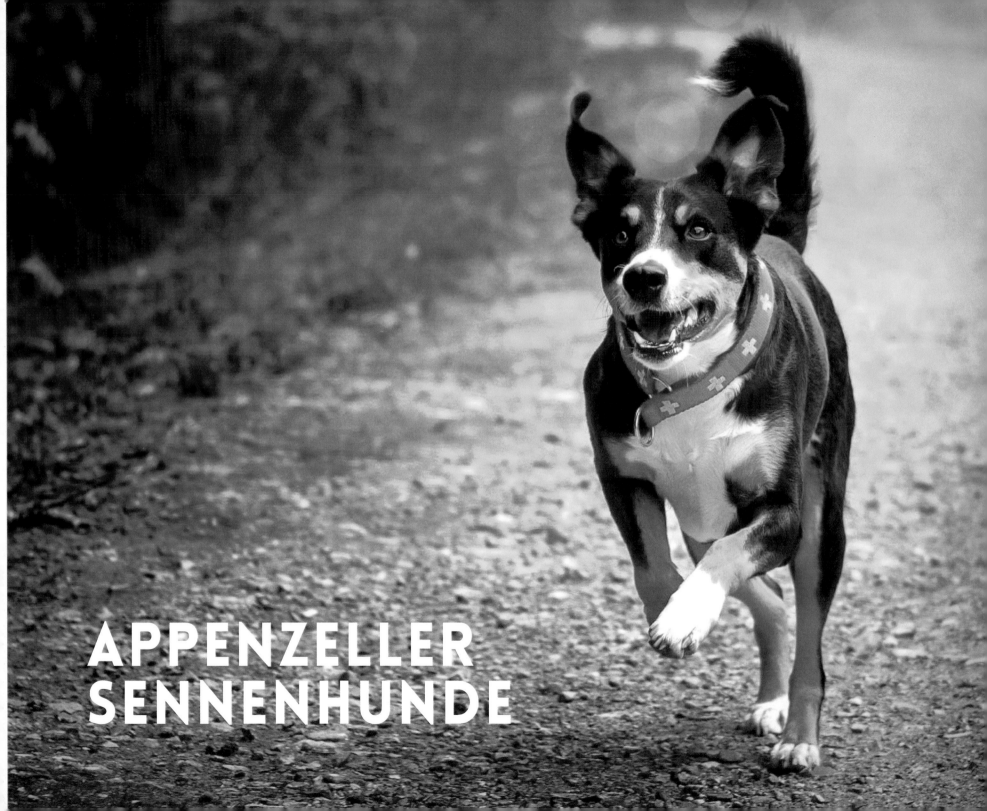

APPENZELLER
SENNENHUNDE

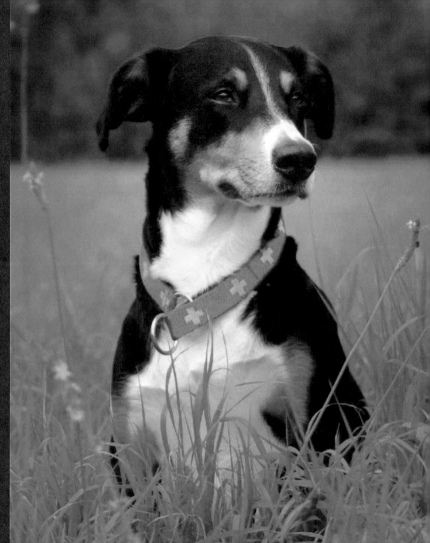

Originated as an all-around farm dog breed, who stayed busy herding the livestock, guarding the farm, and pulling carts in their native Switzerland. Today's Appenzellers still have the energy, smarts, and self-confidence that makes for valuable working dogs — but they're anything but low-maintenance.

Dogs of this breed need lots of exercise, training, and a job to do but, families who can provide the mental and physical stimulation these dogs need will be rewarded with an affectionate, loyal companion. They'll even adore kids; although, they may fall into some herding habits without proper training.

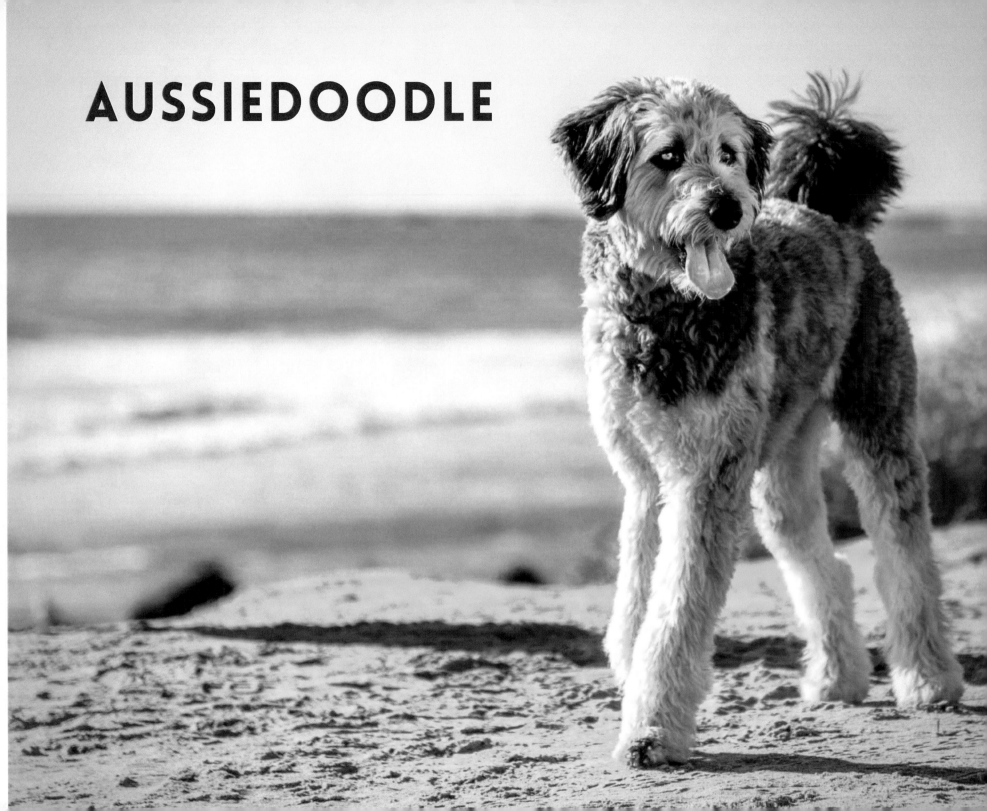

AUSSIEDOODLE

Is a mixed breed dog — a cross between the Australian Shepherd and Poodle dog breeds. Incredibly smart, playful, and loyal. Aussiedoodles go by several names, including Aussiepoo and Aussiepoodle.

These active dogs, often referred to as an "Einstein" breed for their smarts, do well in homes that can provide plenty of attention and exercise. The Aussiedoodle makes an excellent family dog, as long as smaller children know how to safely play with the pup. They are also incredible therapy dogs, given how quickly they bond to a specific human or two.

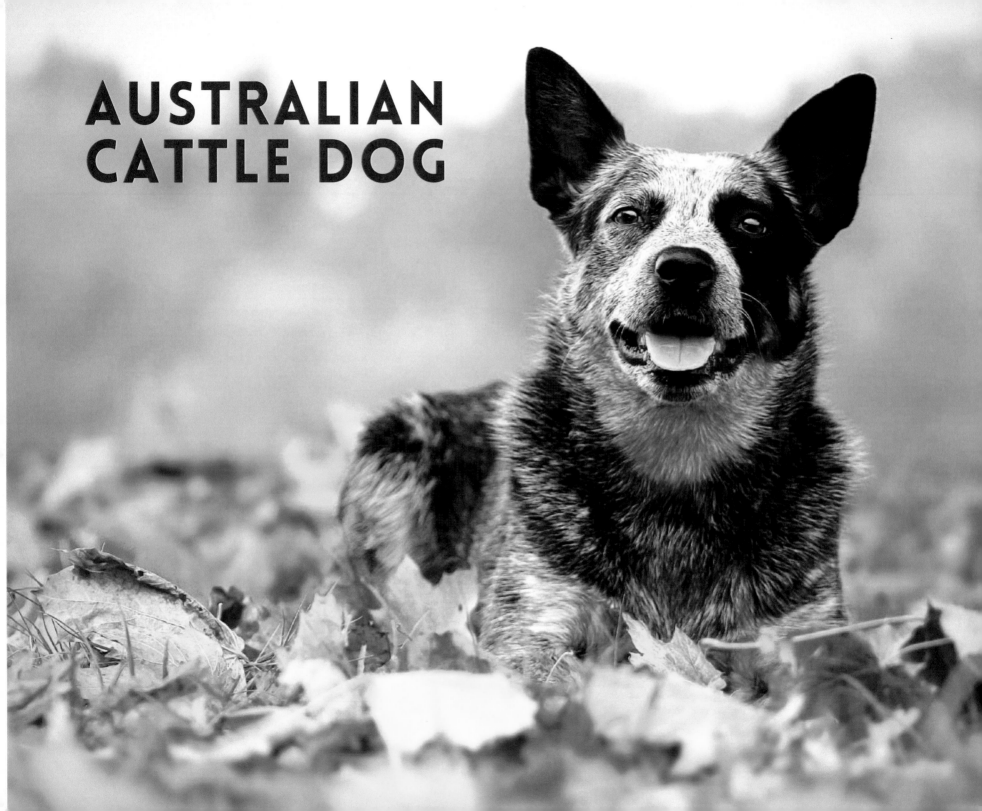

AUSTRALIAN CATTLE DOG

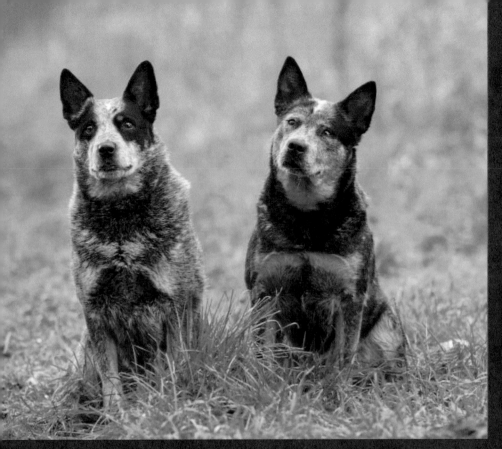

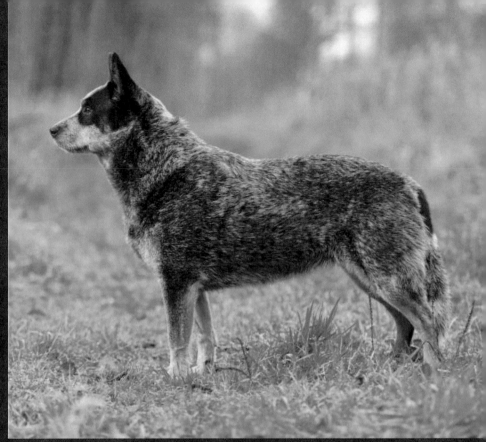

Is an extremely intelligent, active, and sturdy dog breed. Developed by Australian settlers to handle herds of cattle on expansive ranches, they're still used today as a herding dog. They thrive on having a job to do and on being part of all family activities.

Australian Cattle Dogs are loyal and protective of their families, though wary of outsiders. Besides herding work, they do well at canine sports, including agility, obedience, rally, flyball, and flying disc competitions.

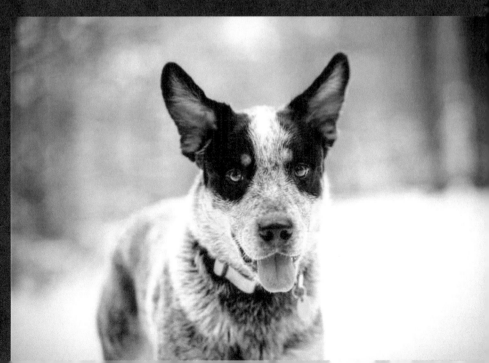

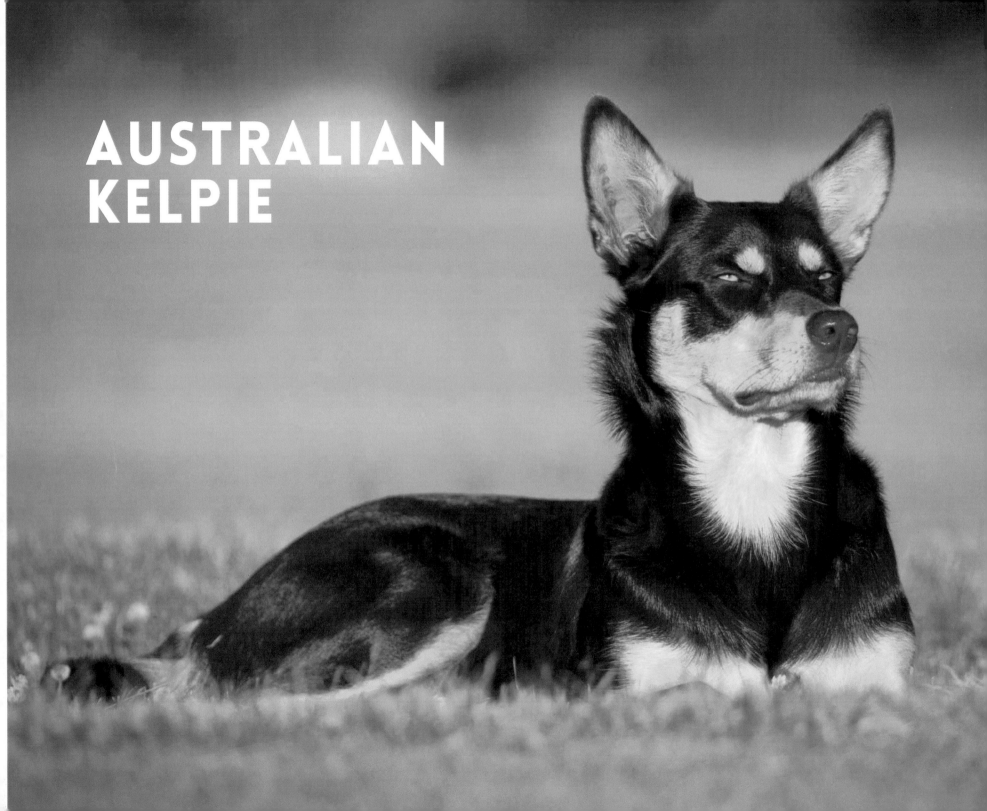

AUSTRALIAN KELPIE

The Australian Kelpie was originally bred to have the energy, intelligence, and independence to herd livestock all day in the hot Australian climate without much need for supervision. They retain those qualities to this day.

People still use Australian Kelpies across Australia and the United States for their herding instincts. That suits these dogs just fine, as they're happiest when they have a job to do. Those who want to keep one of these dogs as a pet would do well to remember that because a bored Australian Kelpie may make their own fun by acting out and engaging in destructive behavior.

AUSTRALIAN
RETRIEVER

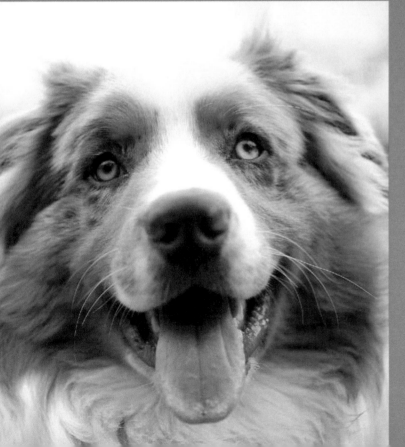

Is a mixed breed dog—a cross between the Australian Shepherd and Golden Retriever dog breeds. Loyal, intelligent, and friendly.

If you're looking for a devoted family dog who's also smarter than your average pooch, the Australian Retriever could be a perfect addition to your household. The mixed breed loves children and is quick to form long-lasting and loving bonds with the humans in their life.

Just be aware that the Australian Retriever is one of the most energetic dogs around—so you'll need to be able to commit to providing lots of exercise and play time and have a suitably spacious living arrangement.

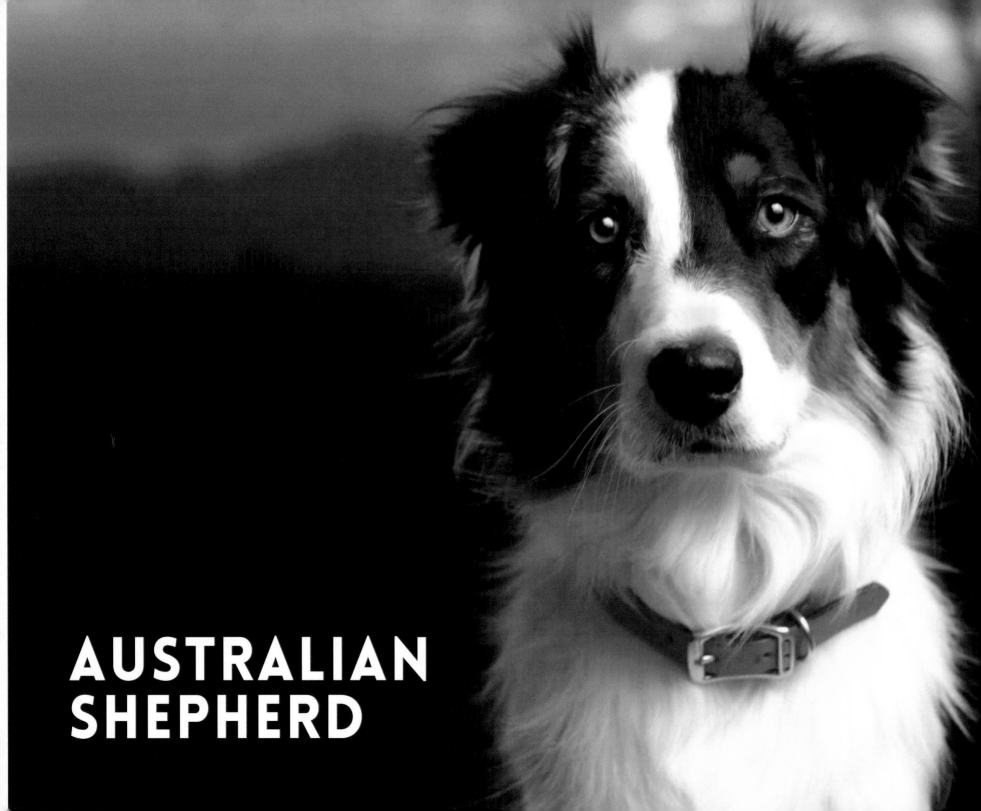

AUSTRALIAN
SHEPHERD

Despite their name, the Australian Shepherd dog breed originated in the western United States, not Australia, around the time of the Gold Rush in the 1840s. Originally bred to herd livestock, they remain a working dog at heart.

The Aussie, as they're nicknamed, are happiest when they have a job to do. They can be wonderful family companions if their intelligence and energy are channeled into dog sports or activities.

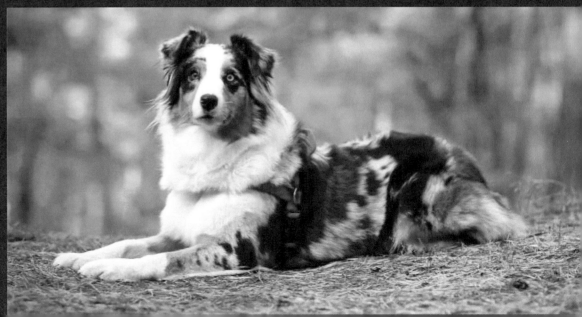

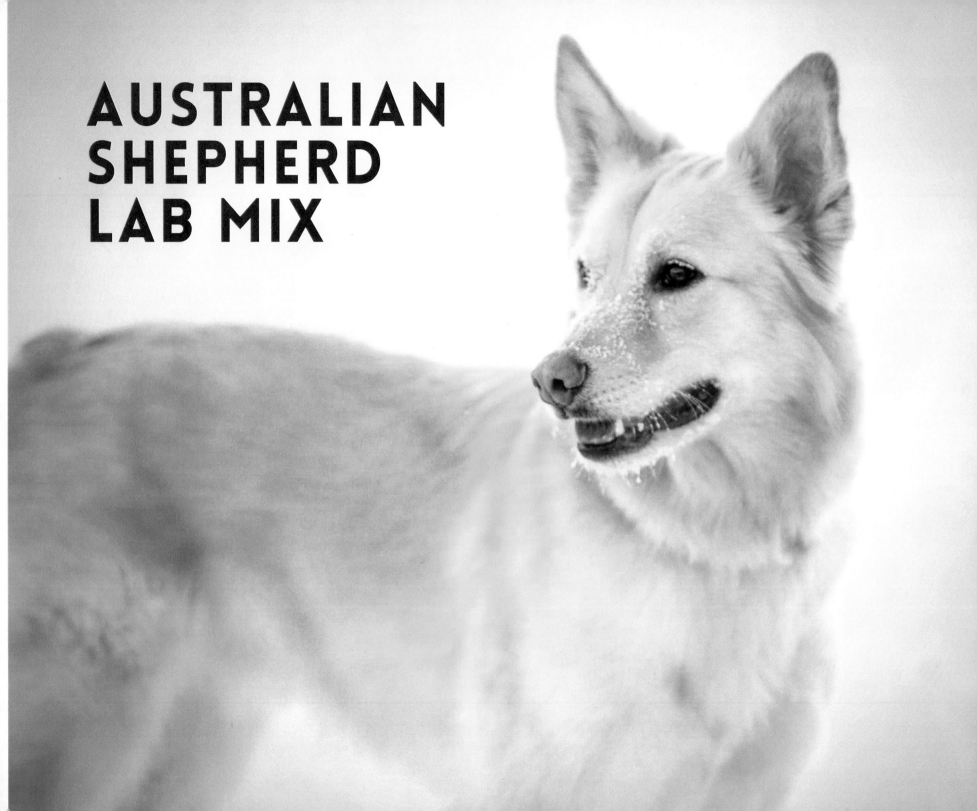

AUSTRALIAN
SHEPHERD
LAB MIX

The Australian Shepherd Lab Mix is a mixed breed dog — a cross between the Australian Shepherd and the Labrador Retriever dog breeds. Medium in size, energetic, and loyal, these pups inherited some amazing traits from both of their parents.

Australian Shepherd Lab Mixes are also called Aussiedors, Australian Shepradors, Aussie Shepradors, Aussie Labs, and Shepradors.

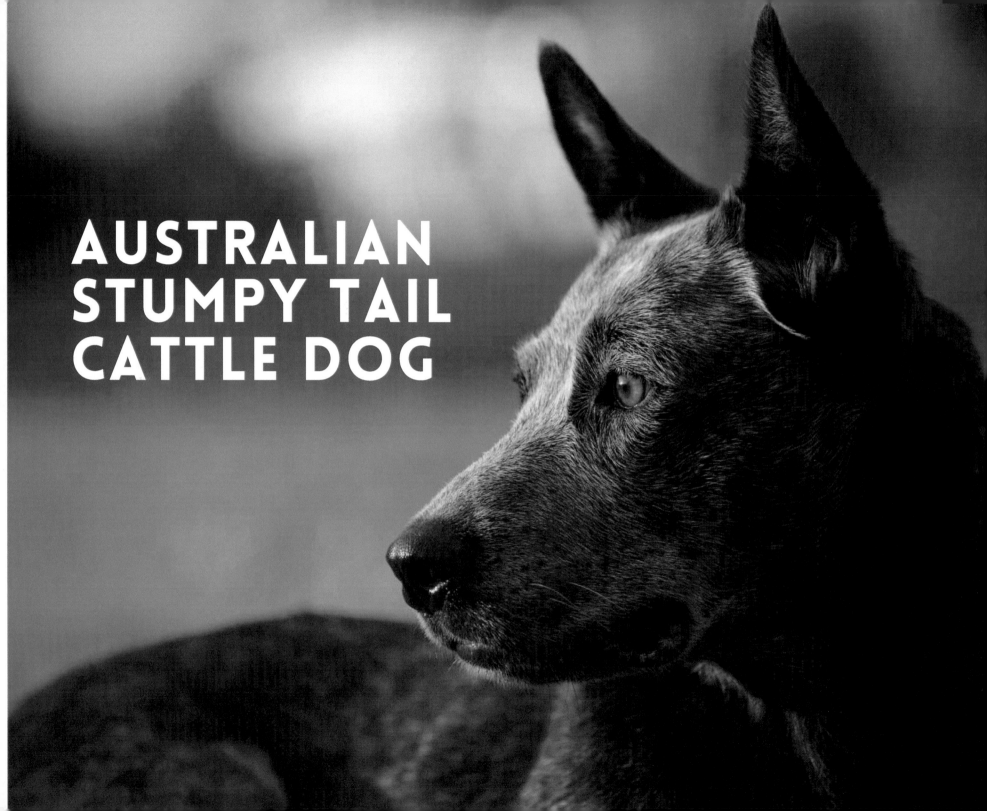

AUSTRALIAN
STUMPY TAIL
CATTLE DOG

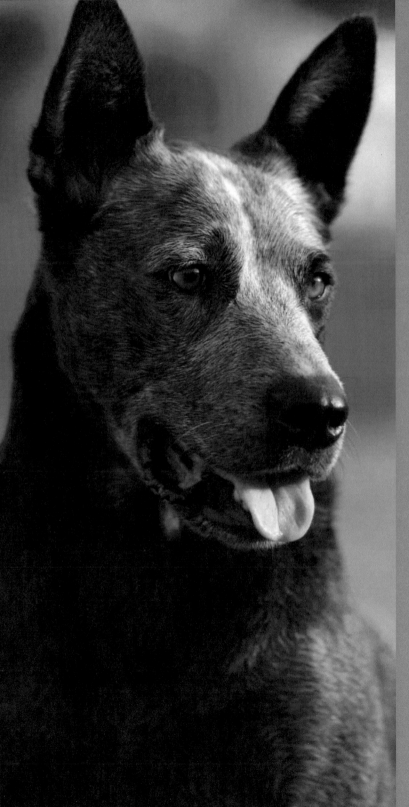

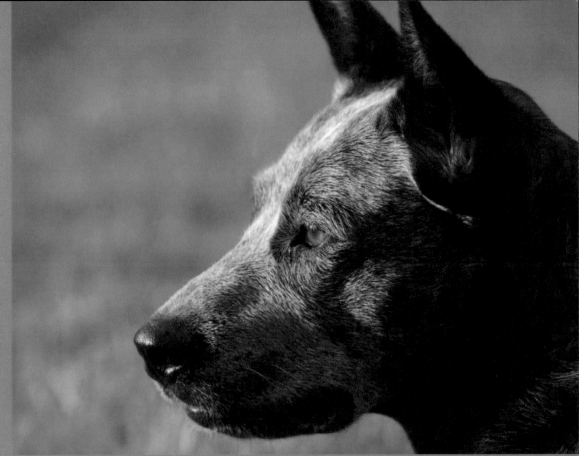

The Australian Stumpy Tail Cattle Dog, named for their characteristic short or sometimes non-existent tail, is a descendant of wild dingoes and domesticated herding dogs from the late 19th century. Although similar to the popular Australian Cattle Dog, the Australian Stumpy Tail Cattle Dog is leaner, tailless, and more alert when it comes to strangers and new situations. This bob-tailed breed goes by several nicknames, including Stumpy, Stumpy Tails, and Heelers.

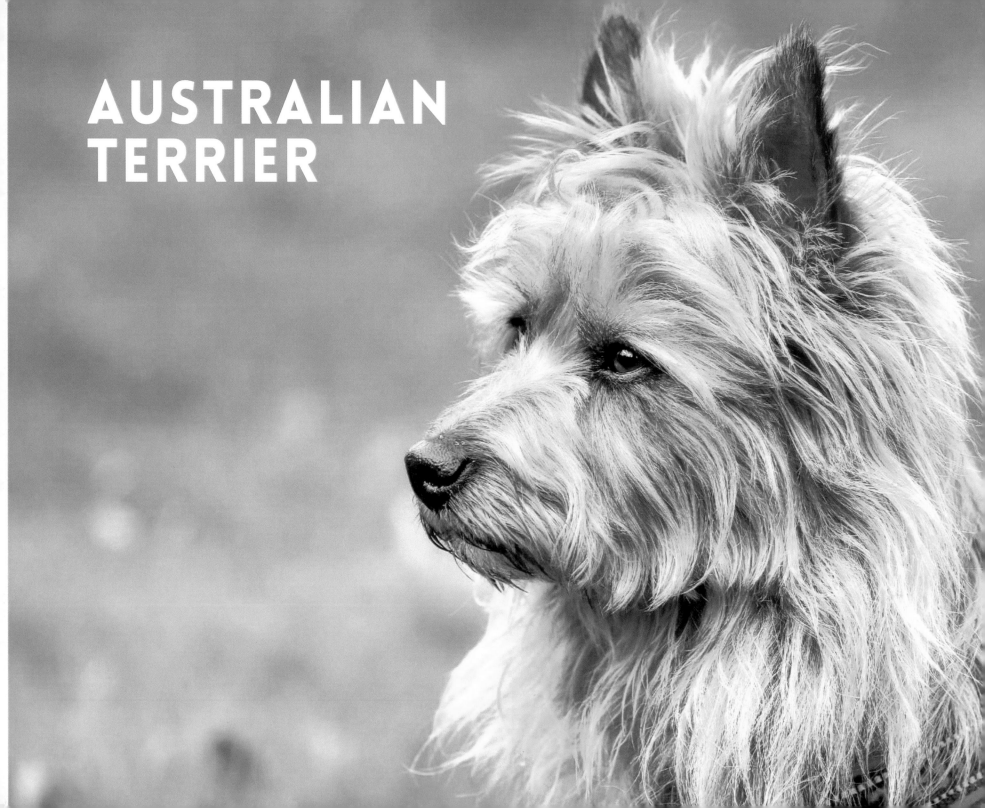

AUSTRALIAN TERRIER

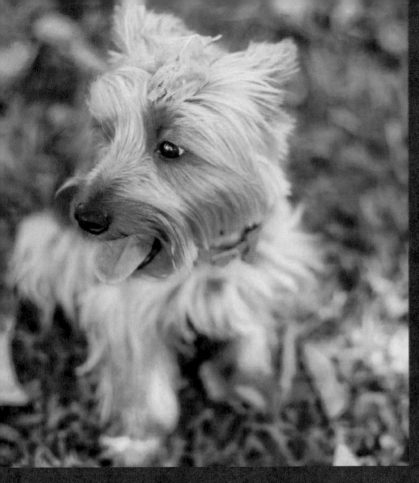

The Australian Terrier was developed in Australia, as their name implies. Bred to hunt rodents and snakes, Australian Terriers were also prized as watchdogs and companions. Today, the breed maintains those same traits: they're delightful companions, fierce earthdog competitors, and conformation and obedience showdogs.

AZAWAKH

A dog breed named for the Azawakh Valley in the Sahara desert where they originated, this is a lean and swift hunter with a regal presence. They're proud but loyal and protective of their home and family. As you may guess from the appearance of the breed and their desert origins, these dogs do well in hot climates. While they love their human families, they can remain aloof around new people.

LUSO
publisher

End of the first volume...